W9-CPY-314

The Little Gift Book of

CANADA

The Little Gift Book of
CANADA

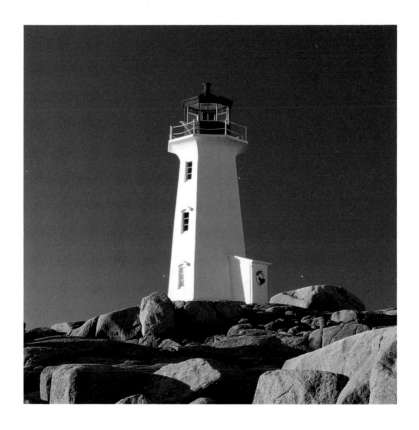

Whitecap Books
Vancouver/Toronto

Copyright © 1989 by Whitecap Books
Whitecap Books
Vancouver/Toronto

Fifth Printing, 1994

All rights reserved. No part of this publication may be re-
produced, stored in a retrieval system, or transmitted, in any
form or by any means, electronic, mechanical, photocopy-
ing, recording or otherwise, without the prior written per-
mission of the publisher.

Text by Elaine Jones
Edited by Brian Scrivener
Cover and Interior design by Steve Penner

Typeset at Vancouver Desktop Publishing Centre Ltd.

Printed and bound in Canada by Friesen Printers,
 Altona, Manitoba

CANADIAN CATALOGUING IN
PUBLICATION DATA
Jones, J.E. (Jeanette Elaine), 1945-
 The little gift book of Canada

 ISBN 0-921061-64-1

 1. Canada - Description and travel - 1981 - Views. I.
Title.
FC75.J66 1989 971.064'7'0222 C89-091406-0
F1017.J66 1989

Cover: Lighthouse, Peggy's Cove, Nova Scotia
J. A. Kraulis

Contents

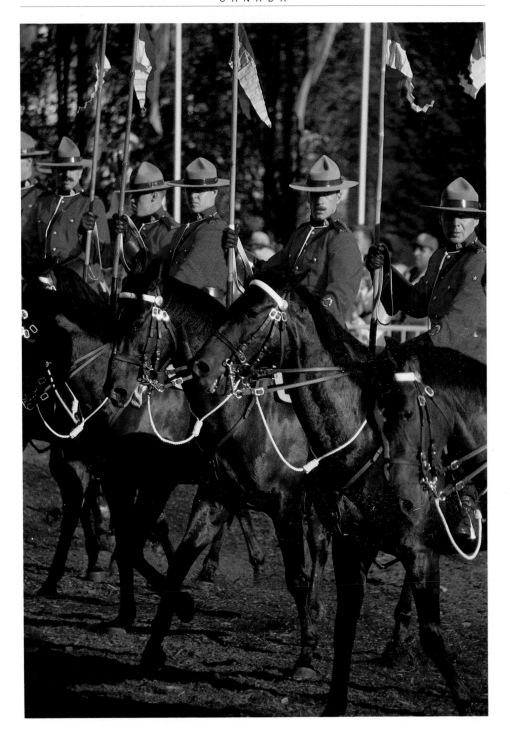

*World famous RCMP Musical
Ride.*

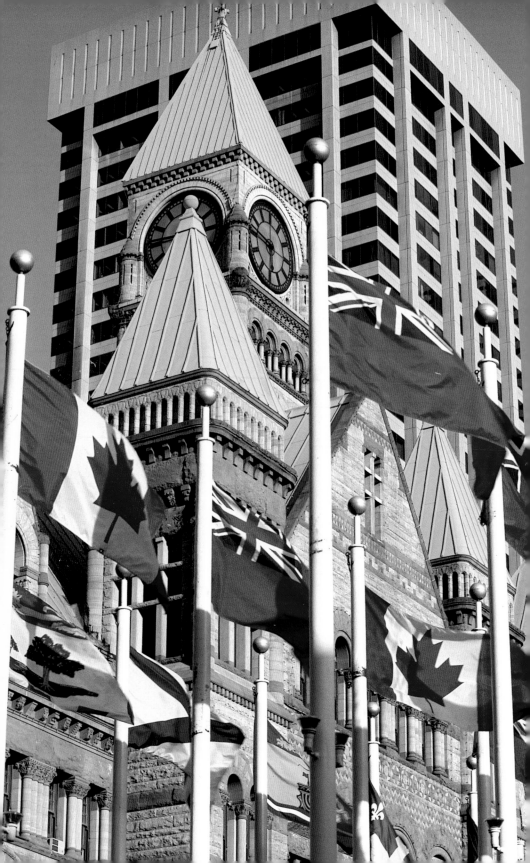

Canada

Canada is a magnificent land. The second largest country in the world after the USSR, it has an area of nearly 10,000,000 square kilometres (3,860,000 square miles). Within its borders lies a diversity of life, landscape and climate that few countries can rival.

Bordered on three sides by oceans—the Pacific, Atlantic and Arctic—Canada possesses a variety of terrain, from rainforests on the west coast to near desert conditions in the southern prairies. Its mountains range from the rugged peaks of the Western Cordillera with their lush valleys and highland plateaus, to the older, more rounded peaks of the Laurentians. Great plains stretch through three provinces and there are rolling central lowlands, vast forests and the treeless tundra of the north.

Canada is a northern country, but its climate varies dramatically. Winters can be long and cold, summers often scorching. Ocean currents to east and west moderate these extremes; the southwest coast of British Columbia is labelled Canada's "banana belt" for its year-round temperate climate.

From the land comes a variety of riches. Forests—from the giants of

Left: *Old City Hall, Toronto, Ontario.*

the British Columbia coast to the extensive pine and fir forests that blanket the north—are the basis of thriving pulp and paper and lumber industries. The prairie provinces provide wheat and a growing roster of other crops. A bountiful harvest of fruits and vegetables is reaped from fertile farming districts across the country.

Under the earth's surface is a storehouse of petroleum, natural gas and minerals, its riches still uncounted. Canada is one of the world's leading producers of nickel and zinc, as well as silver, asbestos, uranium, molybdenum, potash and platinum.

Canada's water resources are remarkable. Its lakes account for one-half of the world's fresh water, and oceans, lakes and rivers abound with a variety of life. Highways of exploration for early settlement, complex river systems today transport the products of processing and manufacturing industries, as well as provide hydroelectric power for domestic use and export.

Not least, the astonishing natural beauty of Canada—its mountains, lakes, plains and the lure of its vast wilderness areas—attracts visitors from around the world.

Bunched near its southern border with the United States, the people of Canada are perhaps its greatest resource. A mixture of nationalities and races that bring many cultural influences to the Canadian identity, its population has often been termed a "mosaic." Native people, Indian and Inuit, and the two main streams of early settlement, French and English, are joined by immigrants from every corner of the globe. And just as the French culture is protected in this officially bilingual nation, so the various nationalities that make up the Canadian people celebrate a diverse cultural heritage within the context of being proudly Canadian.

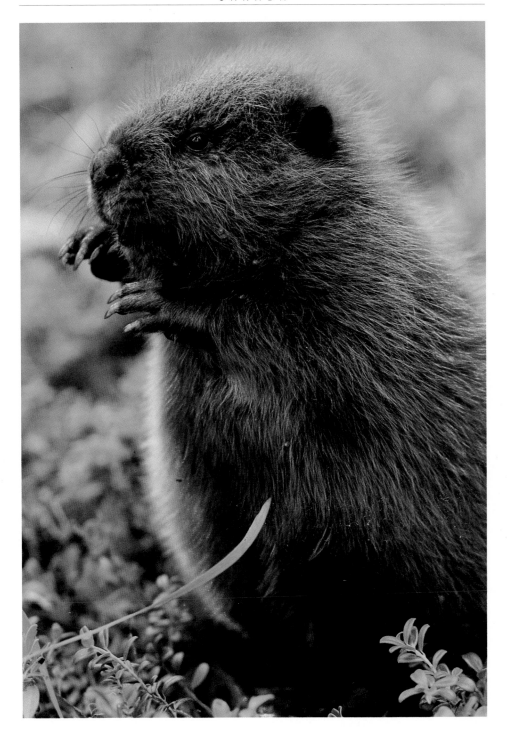

Baby Beaver.

British Columbia

Off the west coast of Vancouver Island, huge Pacific swells race to shore, spending themselves in long hissing waves along miles of fine sand beaches and breaking dramatically against rocky headlands. Protected inland waters provide anchorage for countless commercial and pleasure craft. On the mainland, to the east, rise the coastal mountains, the first in a series of ranges and plateaus that traverse the province. Beyond stretch the great northern plains area and the tundra of the far north. This is British Columbia, Canada's third largest province and its most geographically diverse.

The climate is also diverse. The mild, wet weather of the west coast nurtures the giant firs and cedars of the rainforest and hot, sunny summers in the Interior promote a vigorous fruit-growing industry. A warm offshore current gives the south coast the most temperate climate in the country, and the east coast of Vancouver Island and the islands of the Strait of Georgia enjoy warm, dry conditions year-round. A multitude of bays and marinas attracts thousands of boaters each year.

Victoria, the capital, located at the southern tip of Vancouver Island,

Left: *Okanagan Valley, British Columbia.*

7

enjoys a well-deserved reputation for fabulous parks and gardens; nearby Butchart Gardens is famed worldwide as an example of the gardener's art. Victoria has retained much of its turn-of-the-century architecture and has a decidedly "English" feeling, enhanced by double-decker tourist buses. Situated on a beautiful harbour, the city is a favoured destination for boaters, among many other travellers.

Across the waters of the Strait of Georgia, the bustling port city of Vancouver provides a contrast to Victoria. A metropolitan population of well over one million and its position as a commercial centre give an international air to a city that is also known as a fantastic natural playground. Sailing, golfing, swimming, hiking and skiing are all found within minutes of the city's centre.

Forestry—logging, milling and reforestation—is the province's number one industry. Not surprisingly, tourism runs a close second. Throughout the province, some of the most thrilling scenery in the world is the backdrop to British Columbia's communities. And when swimming, sunbathing and boating are precluded by winter temperatures, skiing, heli-skiing and snowshoeing take over.

The one difficulty that a visitor to British Columbia might have is in choosing a direction of travel. The sun-drenched beaches and wild Pacific beauty of the coast vie for attention with cool mountain vistas and wilderness trails. The romance of the Cariboo, a region of remote cattle ranches and the excitement of the rodeo, competes with the historic interest of the gold rush era in the Interior. Each area has its own allure. Throughout the province, some 350 national and provincial parks provide excellent facilities for enjoying the splendid scenery of Canada's Pacific province.

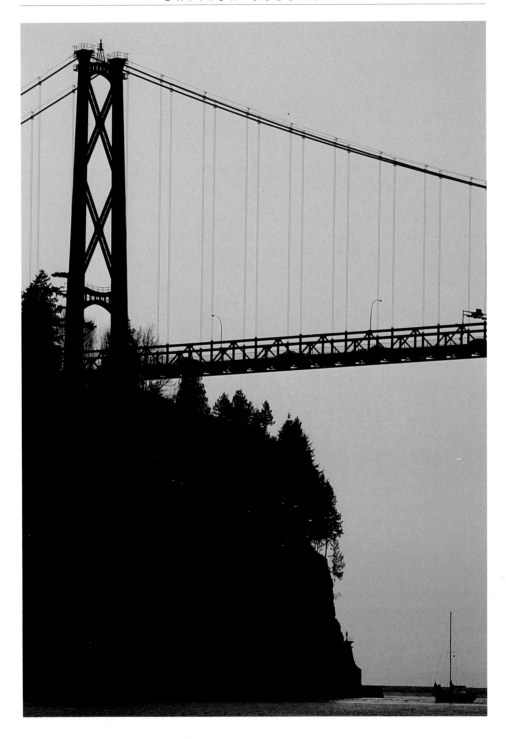

*Lions Gate Bridge, Vancouver,
British Columbia.*

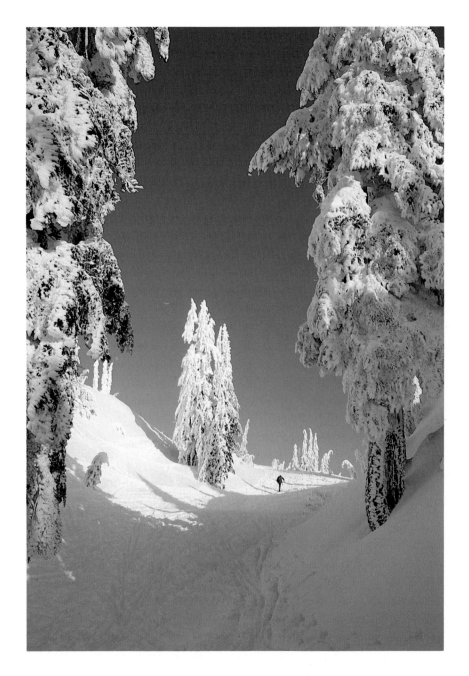

Cross country skiing, Mount Seymour,
British Columbia.

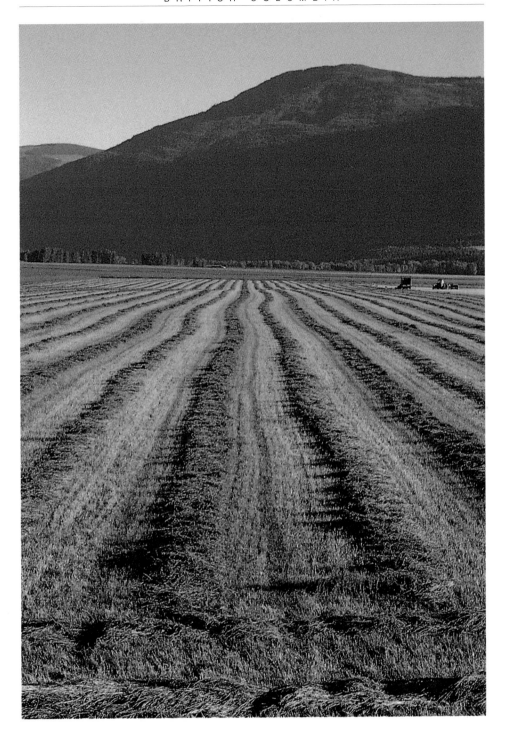

Creston Valley, British Columbia.

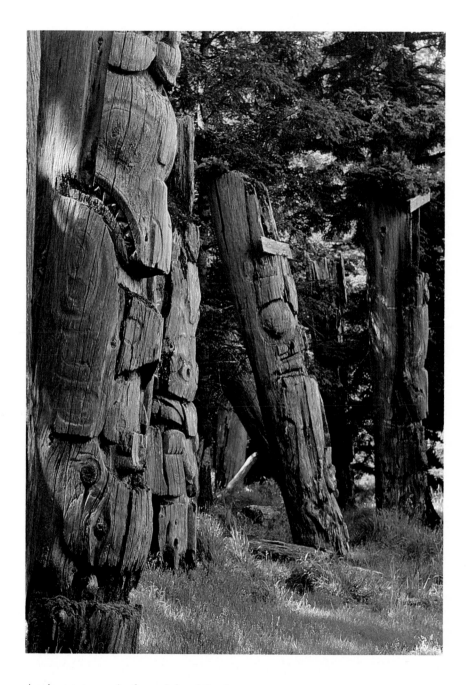

Ancient totems, Anthony Island Park,
Queen Charlotte Islands, British Columbia.

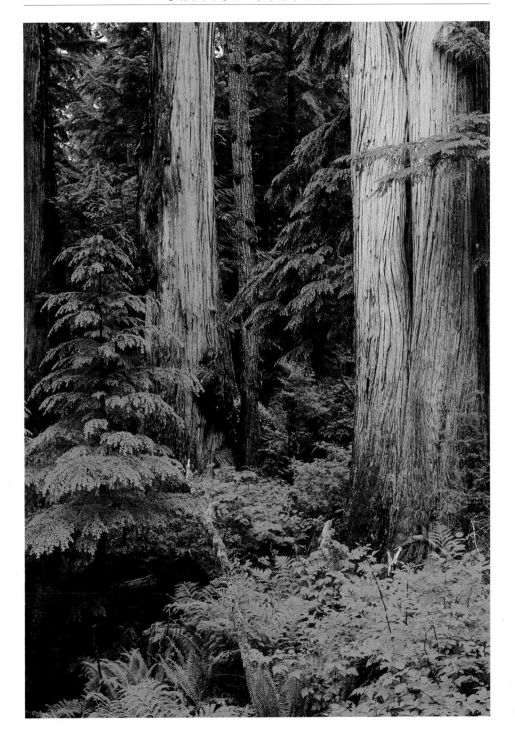

Cathedral Grove, Vancouver Island,
British Columbia.

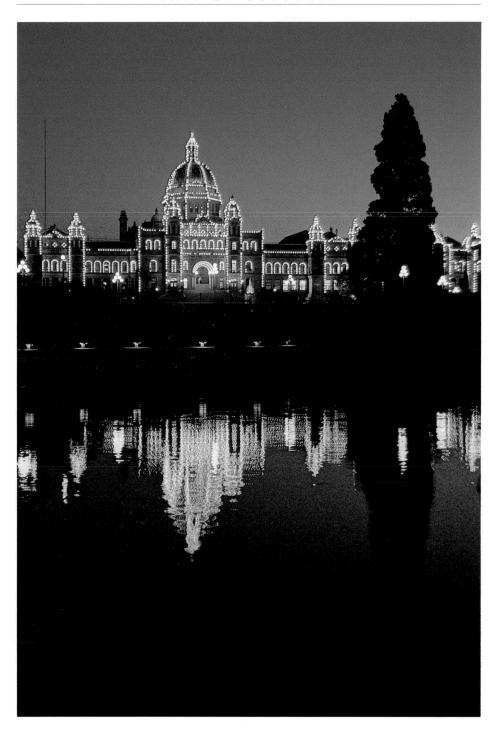

Parliament Buildings, Victoria,
British Columbia.

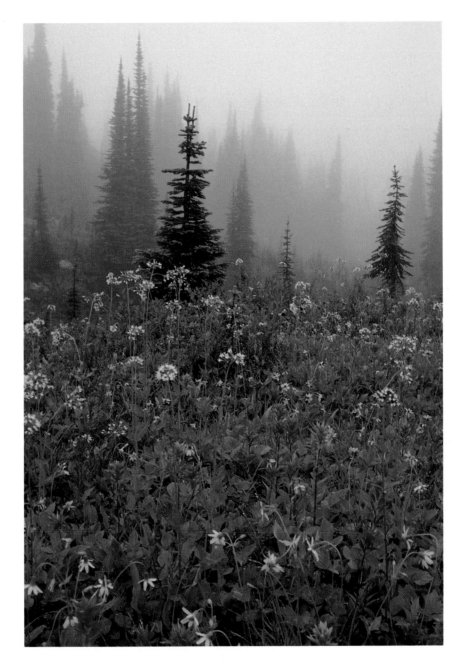

Alpine meadow, Mount Revelstoke, British Columbia.

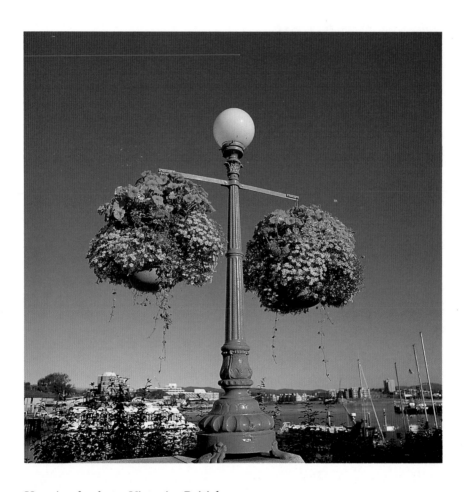

Hanging baskets, Victoria, British Columbia.

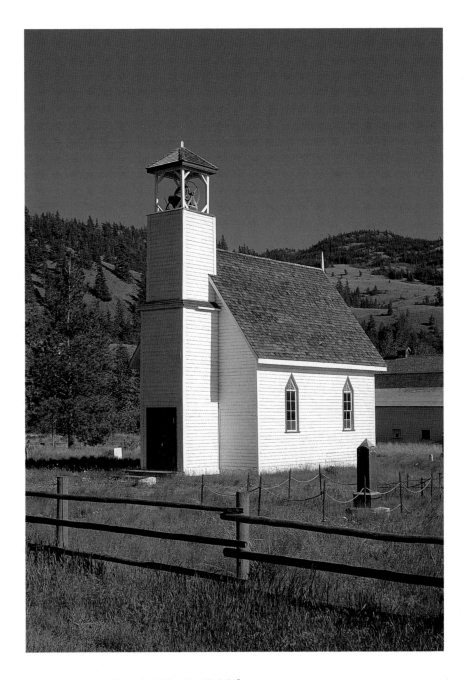

The Murray Church, Nicola, British Columbia.

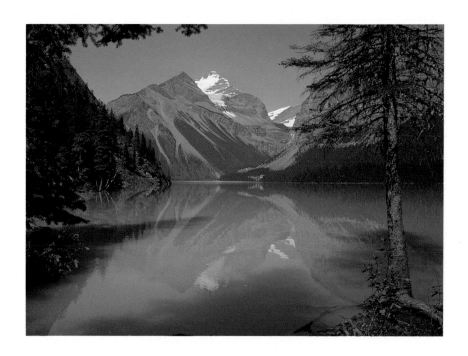

Mount Whitehorn, British Columbia.

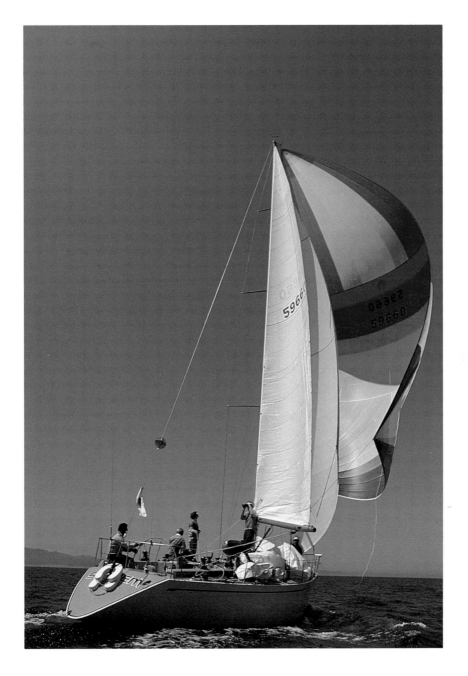

Sailboat racing, Pacific Coast,
British Columbia.

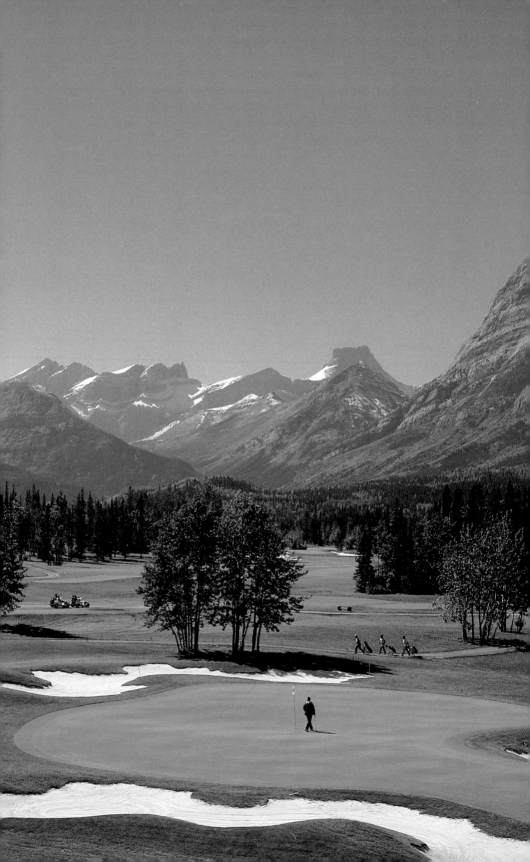

The Rockies

Rising abruptly from the broad prairies, the Rocky Mountains are the easternmost of the ranges that form the Cordillera, a series of peaks, verdant valleys and broad plateaus that extends to the edge of the Pacific. The Rockies have a special grandeur, and each year hundreds of thousands of visitors trek here, in cars or on foot, roughing it with backpacks or staying in luxurious resorts and lodges. Many carry cameras, in hopes of carrying away with them a bit of the magic of these mountains.

Part of the unique appeal of the Rockies is the varying form of these relatively young mountains. Every new turn of the road reveals a different vista, each more entrancing than the last. Each meadow brilliant with alpine flowers, each clear, icy lake and cascading stream renews a sense of awe and wonder at nature's abundance. Everywhere, massive, windswept pinnacles of rock contrast with the minute beauty of alpine meadows and the clear glacial lakes.

Two national parks are located in the Rockies. Banff is Canada's oldest park, established in 1885 after discovery of a sulphur hot springs.

Left: *Banff Golf Course, Alberta.*

Because of the hot springs, clear air and dry climate, the park gained a reputation as a health resort, developing quickly with the advent of the railway.

The elegant Chateau Lake Louise, overlooking a lovely glacial lake, and the Banff Springs Hotel, part of the CPR chain of gracious hotels built at the turn of the century, are two popular resorts. Lake Louise, Moraine Lake in the Valley of the Ten Peaks and Paradise Valley are favourite destinations for travellers. For the visitor, the attractions of Banff do not end with the summer season; the park has some of the best ski slopes in the world, as well as tobogganing, skating, sleighing and curling facilities—not to mention the outdoor hot springs.

Banff is bordered to the west by Yoho and Kootenay national parks; to the north lie Jasper National Park and the Columbia Icefield. Connecting Banff and Jasper townsites is the Icefield Parkway, a 285-kilometre (178-mile) highway of breathtaking scenery.

The sights of Jasper are no less spectacular than those of Banff, but the park is more remote and less developed. Fishing, horseback riding, rock climbing and wilderness camping are popular activities. The vast Columbia Icefield has become a major attraction for visitors. A remnant of the last ice age, it is a slow-moving river of ice up to 330 metres (1000 feet) thick. Snowmobile tours take visitors onto the Athabasca Glacier.

Throughout Canada's early history the Rockies were a barrier separating east from west, making communications difficult in a sparsely populated nation. Today, they can be viewed as somewhat of a unifying force—one of the natural wonders of the country and a source of national pride.

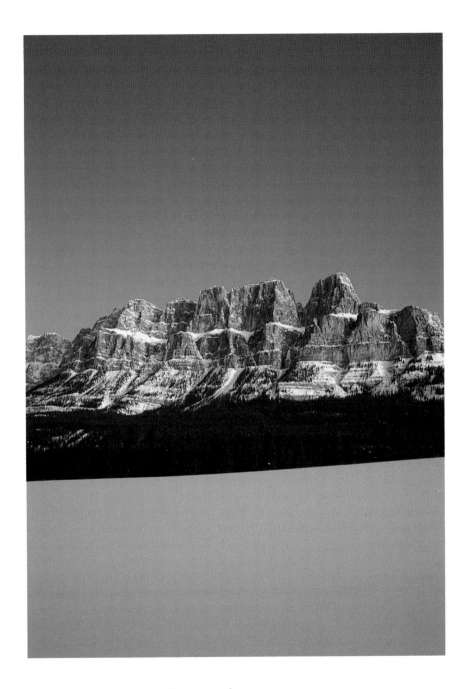

*Castle Mountain, Banff National
Park, Alberta.*

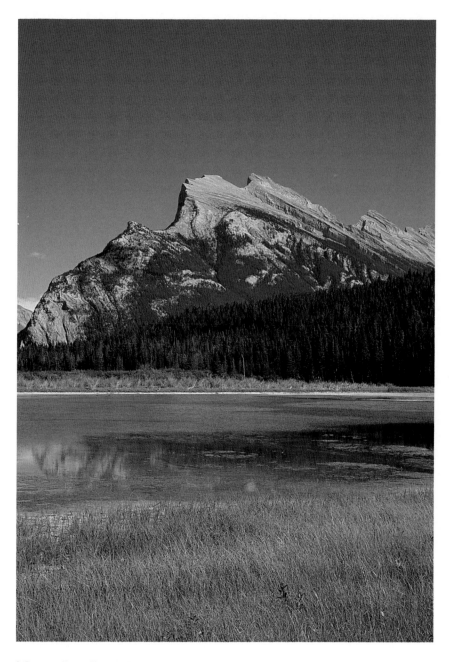

Mount Rundle and the Vermilion
Lakes, Banff National Park.

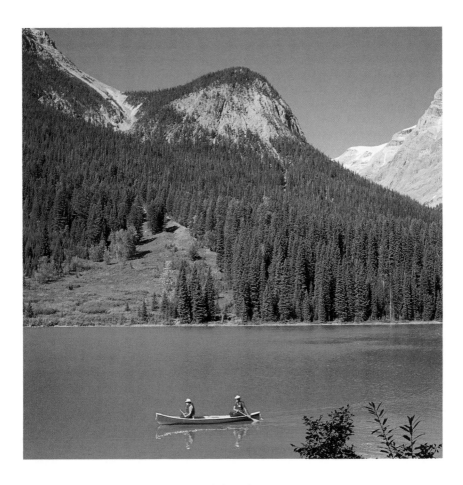

Emerald Lake is justly named for the deep green colour of its glacial waters, Yoho National Park.

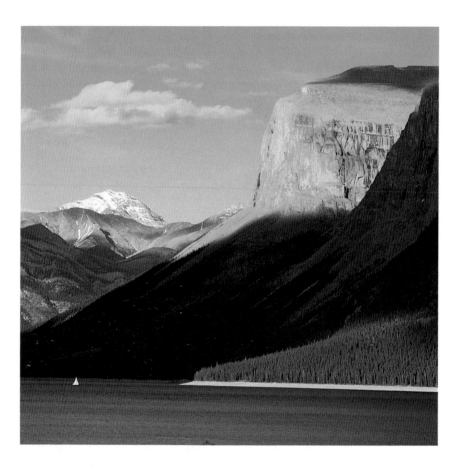

*Lake Minnewanka near Banff. This 19-
kilometre-long lake is the largest in
Banff National Park.*

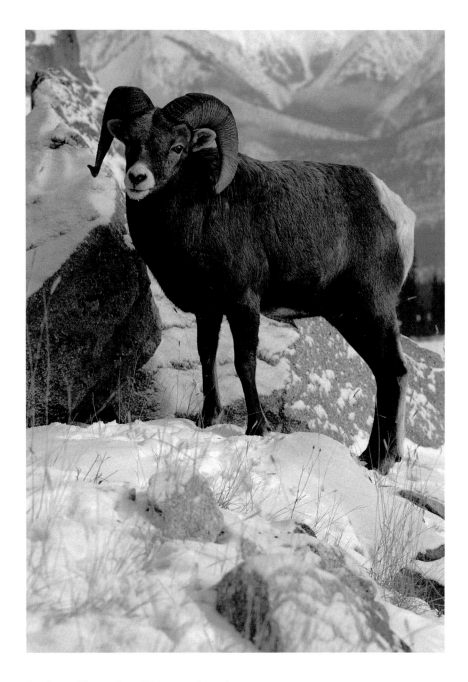

*Bighorn Sheep, Banff National Park,
Alberta.*

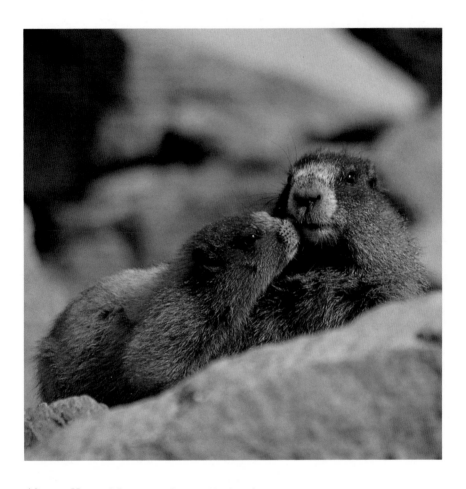

Above: *Hoary Marmots, Jasper National Park, Alberta.*

Right: *Maligne Lake, Jasper National Park, Alberta.*

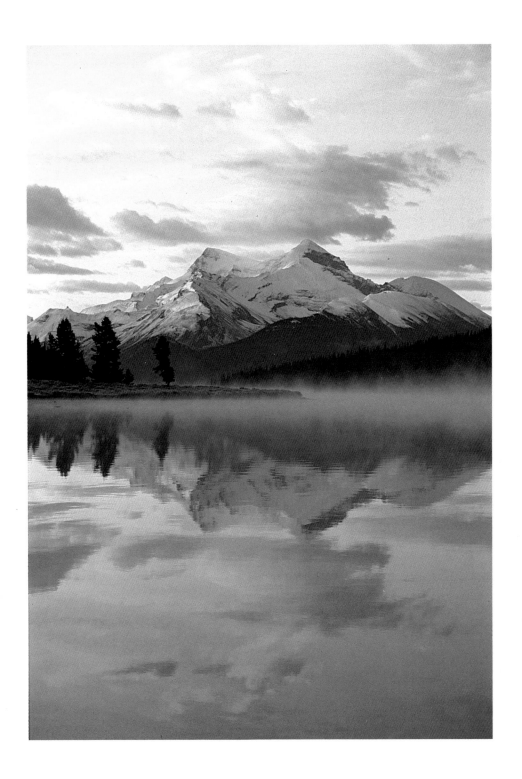

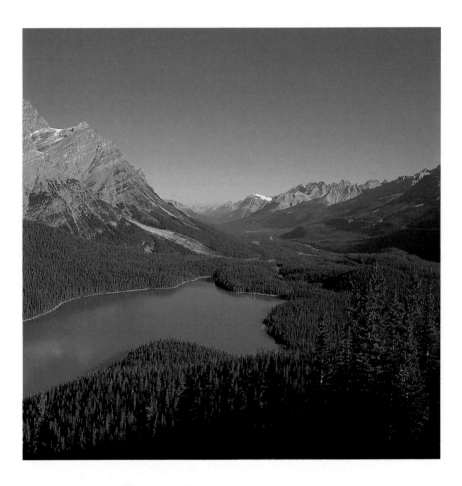

*Peyto Lake, Banff National
Park, Alberta.*

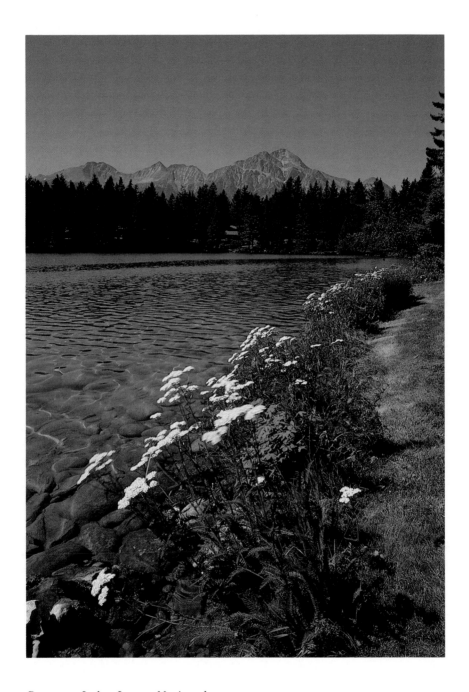

*Beauvert Lake, Jasper National
Park, Alberta.*

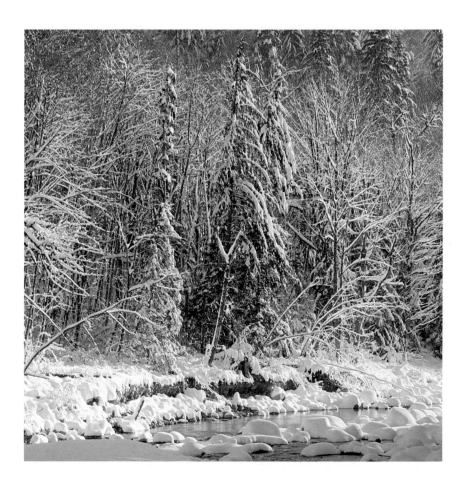

Winter scene, Rocky Mountains.

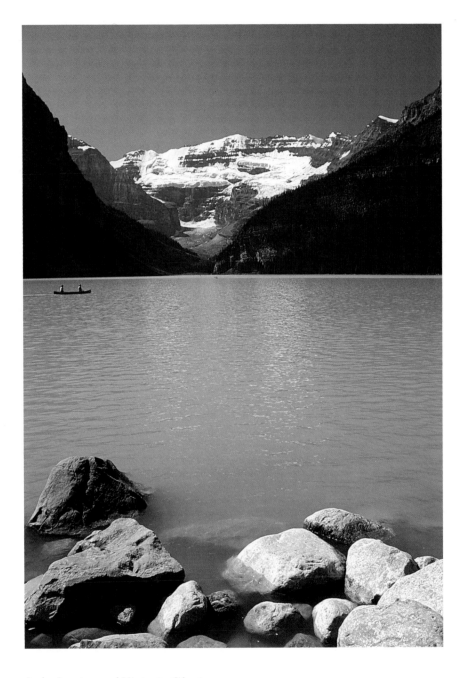

Lake Louise and Victoria Glacier,
Banff National Park, Alberta.

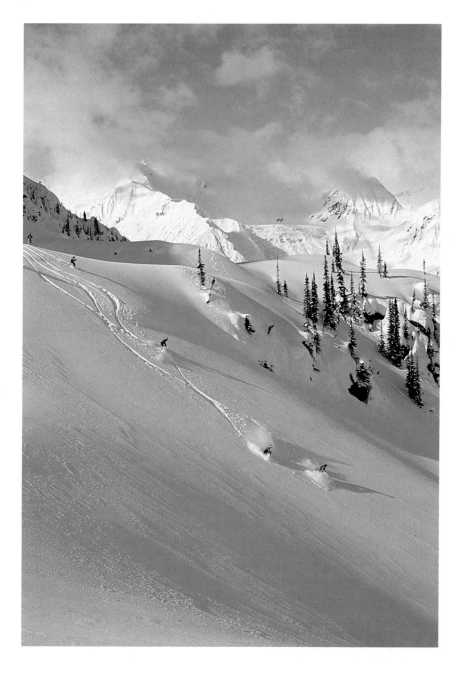

Heli-skiing, The Monashees, British Columbia.

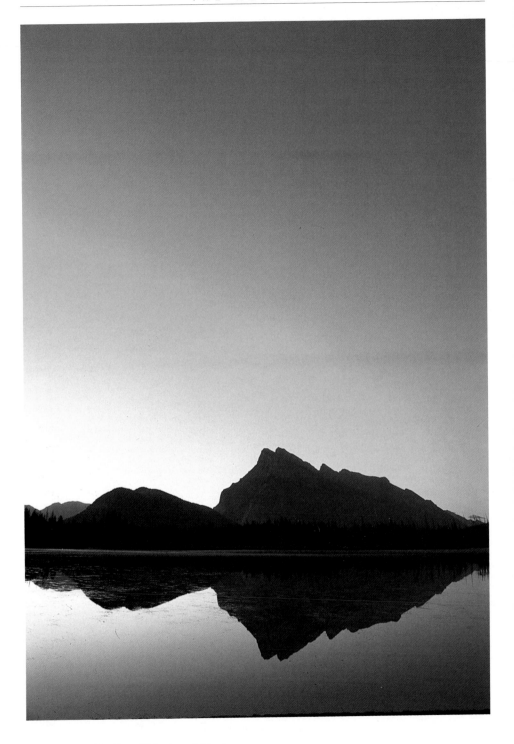

Mount Rundle, Banff National Park,
Alberta.

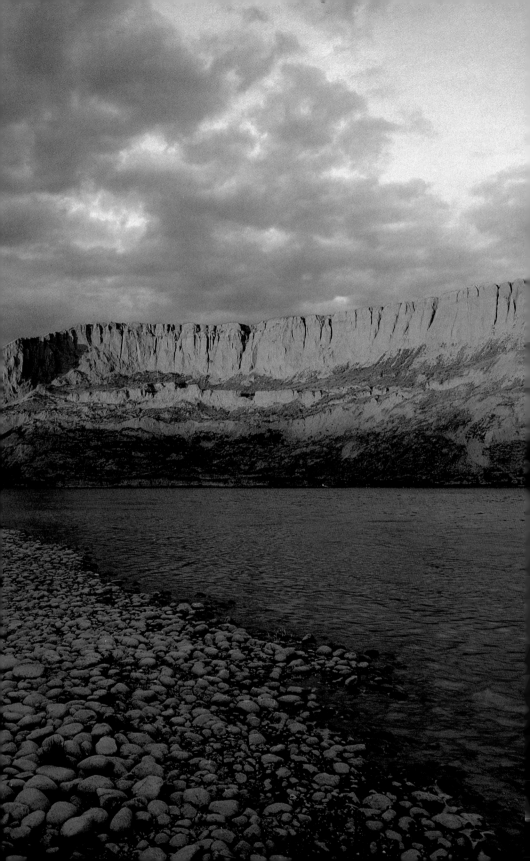

The Prairies

From the foothills of the Rockies to the lake district of eastern Manitoba stretches a broad plain. Here, in the land of the "big sky," the changing patterns of wind and weather hold an endless fascination, and the simplicity of the landscape imparts a unique beauty. These are the prairie provinces: Alberta, Saskatchewan and Manitoba. Known for the superior grade of wheat grown here, they are also suppliers of many other grains—canola, flax, rye—as well as beef, petroleum and minerals.

Alberta was known primarily as a farming and ranching province until the 1950s. The lively city of Calgary was the centre of an expansive cattle ranching industry and the doorway to the Rockies. The capital of the province, Edmonton, languished somewhat in the background until the discovery of major oil deposits in the north. Today Edmonton is known as the "Gateway to the North," a thriving city with an indoor fantasyland—the gigantic West Edmonton Mall. The historic rivalry between Calgary and Edmonton is carried on in a friendly fashion with annual festivals—Edmonton's Klondike Days and the world-famous Calgary Stampede. Alberta also claims some of Canada's most beautiful

Left: *South Saskatchewan River, Alberta.*

and interesting areas, including the Rockies and Dinosaur Provincial Park, the site of extensive fossil remains.

Saskatchewan is truly an agricultural province, although production of oil and natural gas and mining for potash, uranium and coal supplement the economy. The wide central agricultural belt is characterized by endless stretches of golden fields, complemented by the intense blue of the summer skies. To the south is Cypress Hills, a surprising region of rolling hills and forested valleys that rises out of a semi-arid plain. The capital city, Regina, centres on manmade Wascana Lake. A large park surrounding the lake houses the Legislature Buildings, the Museum of Natural History, the University of Regina and Saskatchewan's Centre of the Arts. The city was once the headquarters of the original Royal Canadian Mounted Police, and the training depot is still located here, as well as a museum. Saskatoon, the "City of Bridges," is well situated on the winding Saskatchewan River. Saskatchewan's largest centre, it is home to the University of Saskatchewan.

Manitoba, located almost equidistant from the Pacific and the Atlantic, marks the transition between east and west. At its western border, it shares the fertile grain-growing soil of the prairies. To its east, it blends with the rocky, evergreen-clad lands of northern Ontario. The southern part of the province is largely agricultural, but Manitoba is noteworthy for its immense water resources and forested northern areas. Large lakes—Winnipeg, Manitoba and Winnipegosis—dominate the map, and countless smaller lakes extend to the province's shoreline on Hudson Bay. Winnipeg, the capital and largest city of Manitoba, is a sophisticated centre that celebrates the diverse cultural heritage of the province and is the home of the renowned Royal Winnipeg Ballet.

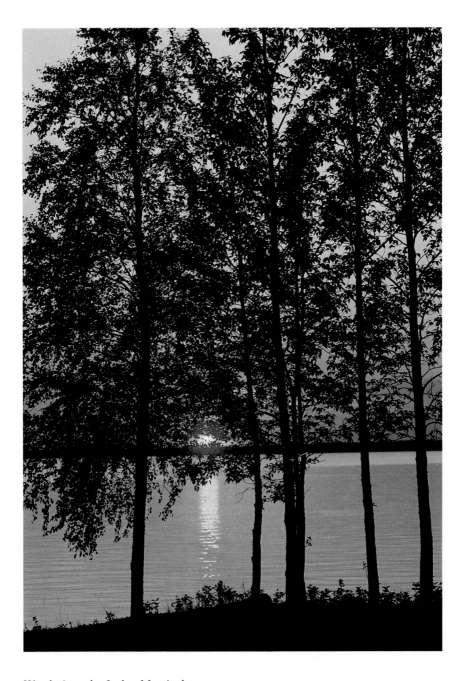

Waskaiowaka Lake, Manitoba.

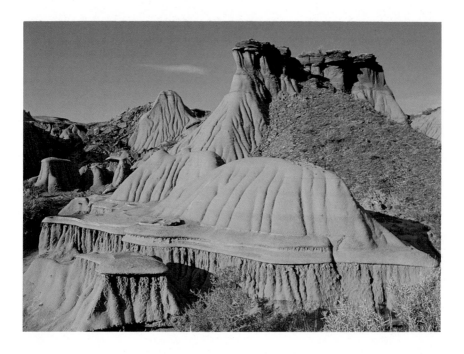

Above: *Dinosaur Provincial Park,
Alberta.*

Right: *McKay Lake, Saskatchewan.*

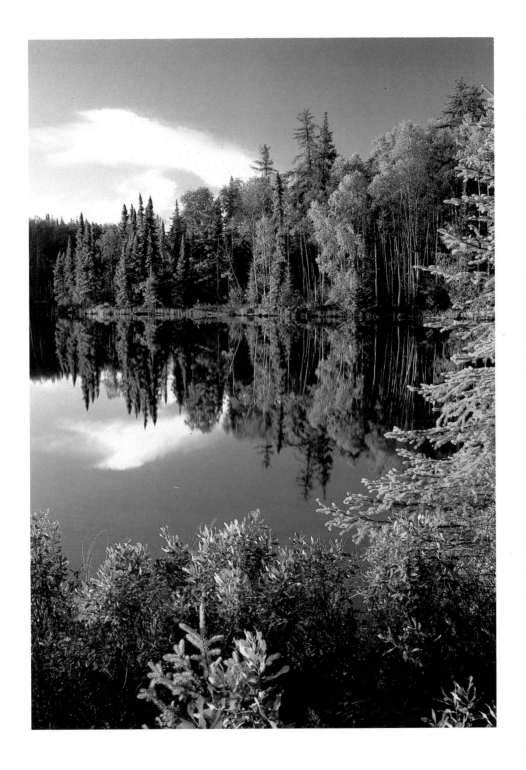

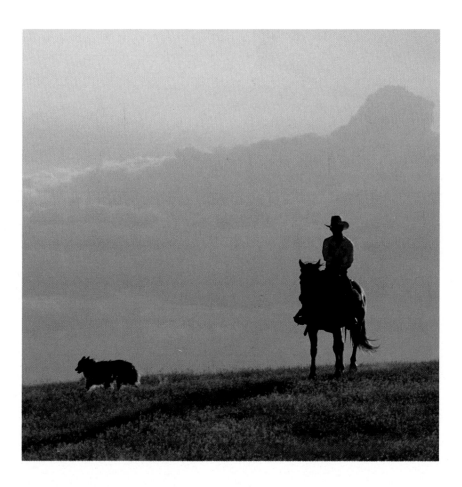

Cowboy and his dog, Alberta.

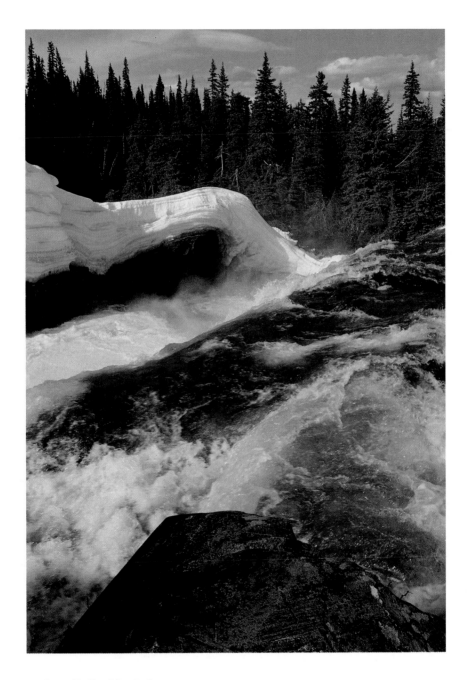

Pishew Falls, Manitoba.

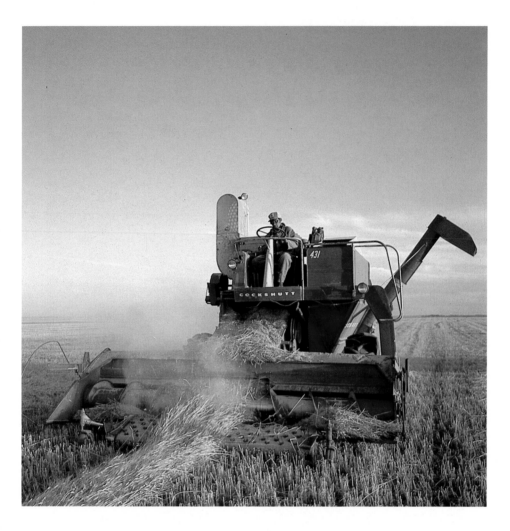

Above: *Harvest, Saskatchewan.*

Right: *Manitoba Legislature Building, Winnipeg, Manitoba.*

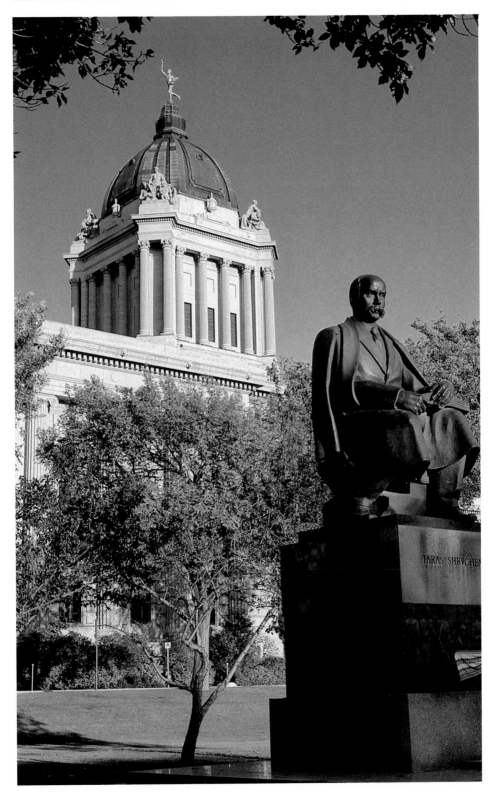

Above: *Approaching the Rockies,*
Beiseker, Alberta.

Right: *Ukrainian church, Prince*
Albert, Saskatchewan.

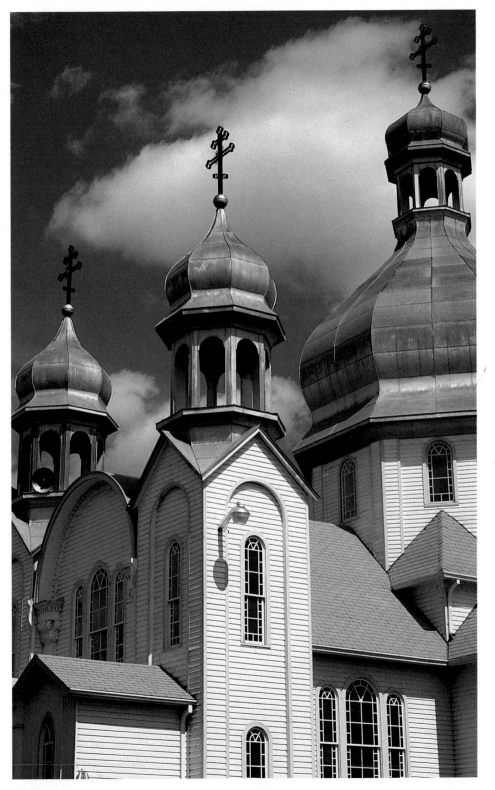

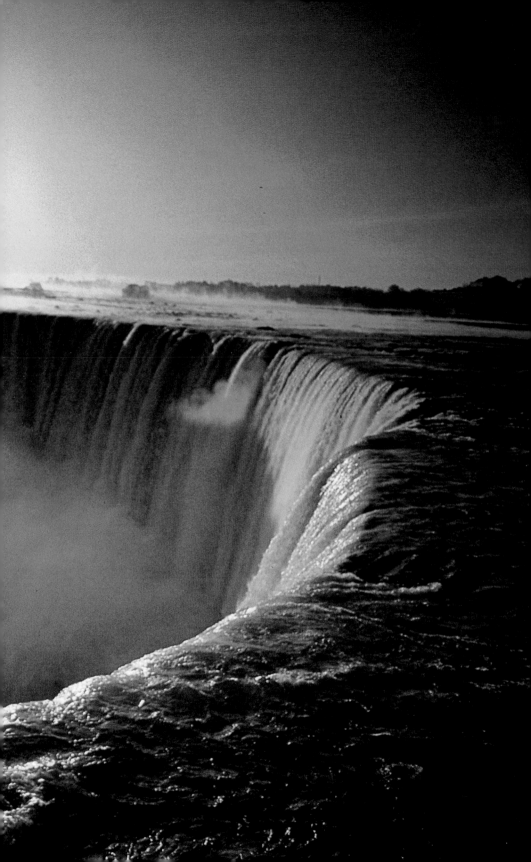

Ontario

Canada's second largest province and its most populous, Ontario is a land of great contrasts, one rich in human and natural resources. Dense populations cluster around the Great Lakes and the border with the United States, yet what is termed northern Ontario—nearly nine-tenths of the province's area—is virtually unexplored wilderness, a deeply forested land of lakes, streams and barren rock that stretches to the salt water of Hudson Bay. Ontario also boasts the southernmost point in Canada—Point Pelee and its offshore islands, which extend into Lake Erie.

Ontario borders four of the five Great Lakes. The highly industrialized area around lakes Ontario and Erie was once the major source of Ontario's prosperity. Today the mineral-rich rock of the north yields up its treasures—iron, uranium, copper, lead, zinc, nickel, cobalt, titanium and asbestos—and new communities have been established to service these industries.

The area around the Great Lakes also has a high concentration of farmlands—many dating back to the first settlers. Much of Canada's

Left: *Niagara Falls, Ontario.*

vegetable crop is produced here, and seasonal open-air markets are a common sight on the byways.

The province's capital and largest city, Toronto is a major economic centre and one of Canada's busiest ports. Its reputation for being strait-laced—"Toronto the Good"—has been outgrown in the last few decades, as the city has taken its place as an international centre. Its name comes from a native word for "meeting place," and the city is truly a meeting place in many senses, attracting business from around the world and possessing an exciting blend of cultures. Its world-famous CN Tower—the world's tallest free-standing structure—and the harbourfront developments are just two of its many attractions.

Ontario is also the home of Ottawa, Canada's capital city. Across the Ottawa River is its twin city, Hull, in the province of Quebec. Ottawa's function as the capital is evident in the imposing Parliament Buildings overlooking the river and the many cultural facilities of the city. The large number of museums, universities, historic sites and other cultural venues throughout Ontario reflect the long history of the province and its high population level.

Ontario's link to the ocean is the Great Lakes-St. Lawrence Seaway, a network of rivers, canals and lakes that connects Ontario to western Canada and the U.S. and allows the shipment of goods such as wheat, ore and automobiles on ocean-going vessels. The western terminus is Thunder Bay, one of Canada's largest ports—some 4,000 kilometres (2400 miles) from the ocean! One of the most fascinating parts of this system is the Welland Canal, a series of locks created to bypass the spectacular Niagara Falls, long a magnet for visitors. Ontario is richly endowed with water, which makes up one-sixth of its surface area. Its waterways were once the means of exploration; today they support much of the province's industry and are well used for recreational pursuits, forming an integral part of the natural beauty of Ontario.

*Winter scene, Lake Superior,
Ontario.*

Above: *Holland Marsh, Ontario.*

Fall colours in Algonquin Park.

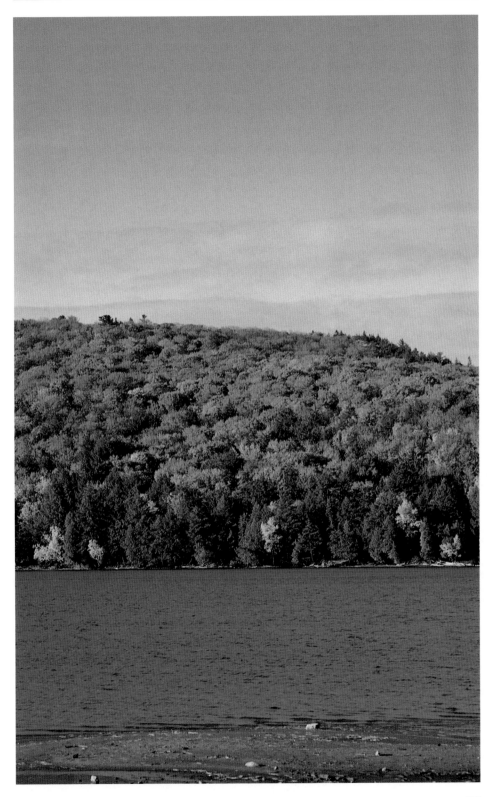

Eaton's Centre, Toronto, Ontario.

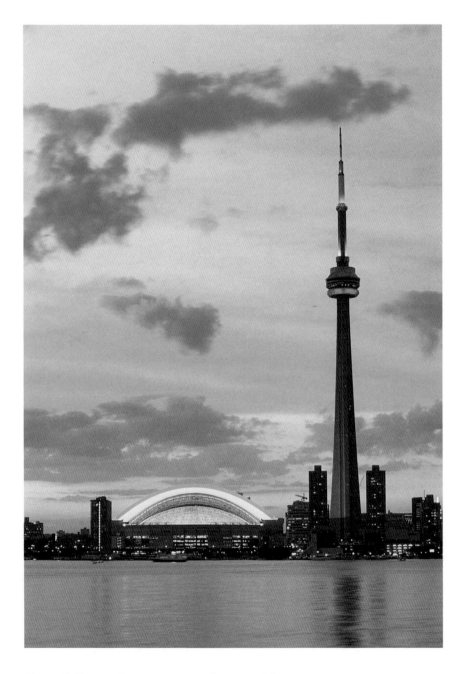

Two of Toronto's greatest modern architectural marvels, Skydome and the CN Tower.

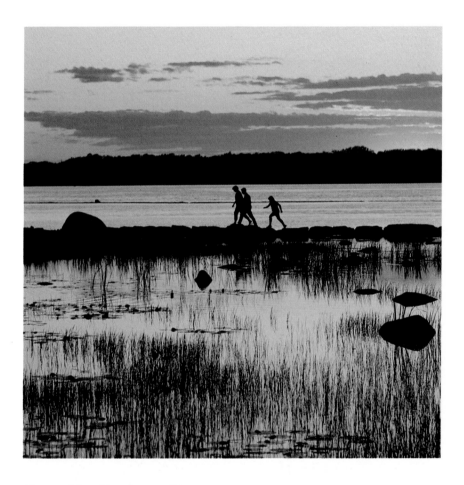

Above: *Marshland, near Ottawa, Ontario.*

Right: *Rideau Canal, Ottawa River, Ontario.*

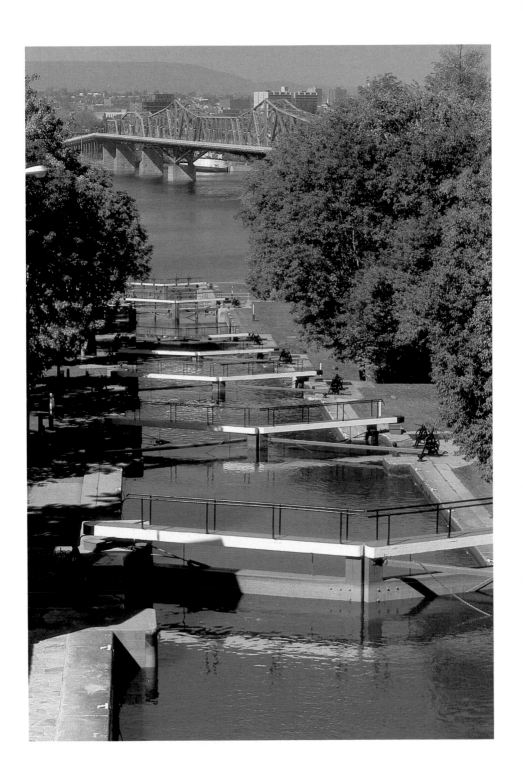

Above: *Lake of Two Rivers,*
Algonquin Park, Ontario.

Right: *St. Mark's Parish Hall,*
Niagara-on-the-Lake, Ontario.

Flowering crabapple,
Ottawa, Ontario.

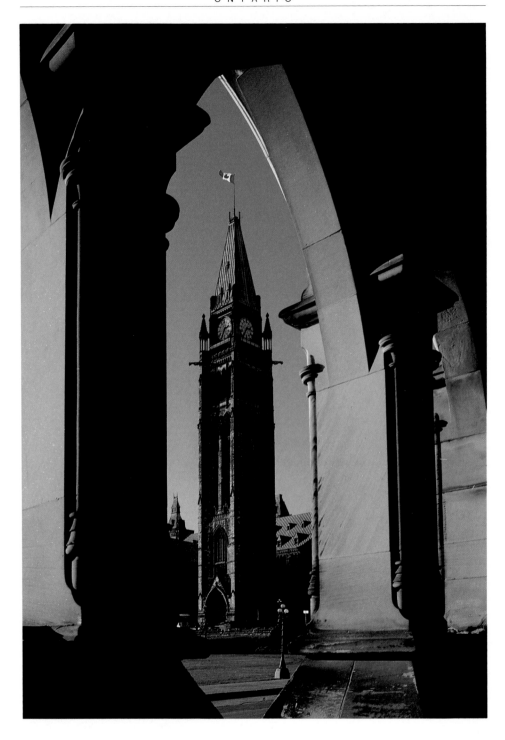

Parliament Buildings, Ottawa,
Ontario.

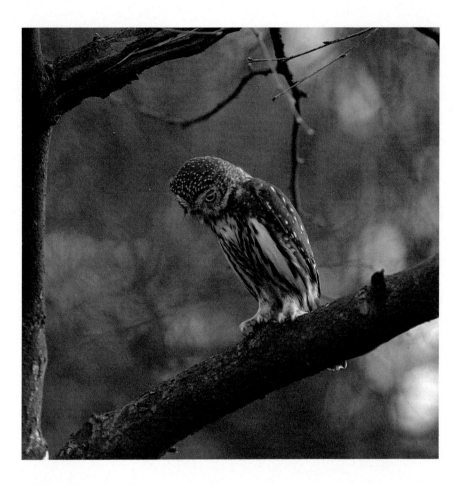

Above: *Boreal owl, Ontario.*

Hardy Lake Provincial Park in Muskoka.

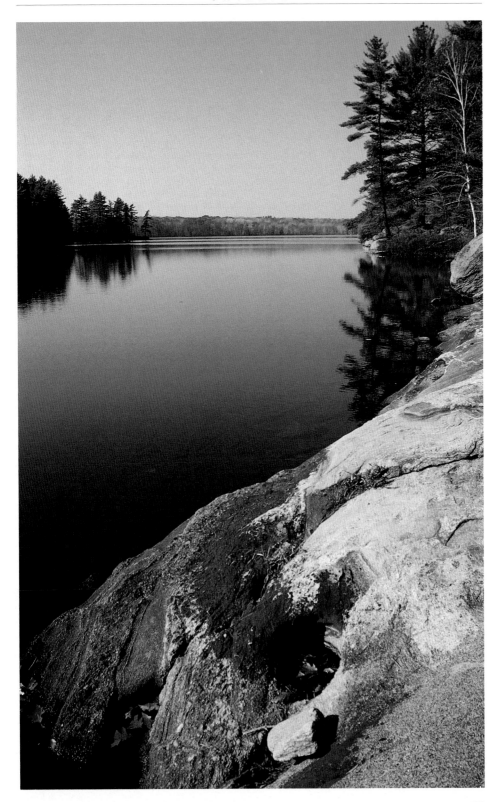

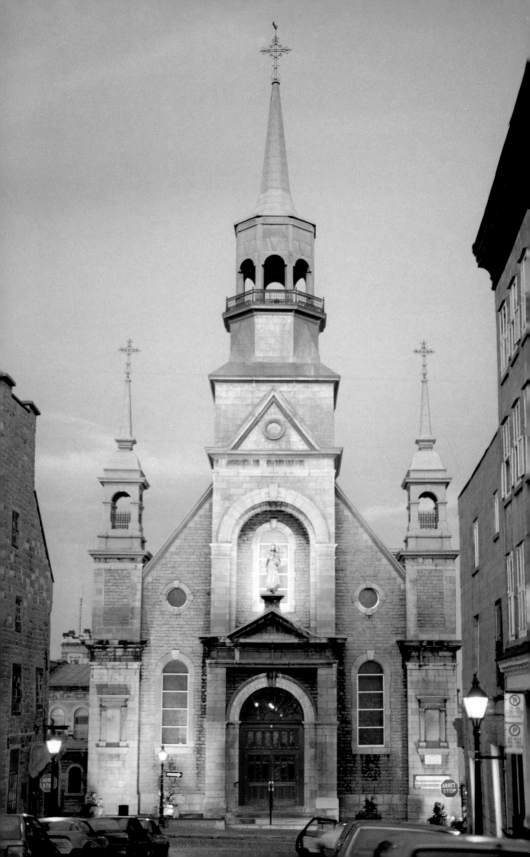

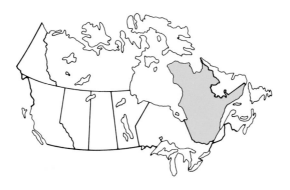

Quebec

Canada's largest province, Quebec is the seat of French culture in Canada. Montreal, with a population of close to 3,000,000, is the second largest French-speaking city in the world, after Paris. Quebec's population has, for more than three centuries, held fast to the lowlands bordering the St. Lawrence River. The northern part of the province is an immense hinterland dotted with isolated settlements.The industries of the north—pulp and paper production, mining and the harnessing of rivers for hydroelectric power—are mainstays of Quebec's economy. Its greatest river, the St. Lawrence, transports the province's manufacturing output to the world's markets.The pastoral countryside of southern Quebec is a charming area. Along the rivers the land is divided into long narrow parcels, each retaining a tiny strip of river frontage—a method of farming that dates back to colonial times. In some areas, the sap of the maple tree is still tapped each spring. It is made into a confection that is sold throughout the world—real Canadian maple syrup.Historic Quebec City, the province's capital, embodies much of the allure of Quebec. Founded in 1608, it is the only walled city in North America.

Left: *Notre Dame Church, Old Montreal, Quebec.*

Its location at the sudden narrowing of the St. Lawrence is reflected in its name—an Indian word, kebec, the place where the water narrows. The modern city is a year-round port and an active commercial centre, but the Upper Town is what draws many visitors. Dominated by the ramparts of the Citadel and the roofline of the Chateau Frontenac, its narrow, cobblestone streets and the stone buildings of past eras can be enjoyed from horse-drawn carriages.No other Canadian city can rival Montreal for sparkle, sophistication and international flair. Quebec's largest city, Montreal was first established as a mission, later becoming the hub of the fur trade. Today, it is a vital, cosmopolitan city, a major centre of commerce by day, and home to a lively mixture of theatre, live music and stylish restaurants that are open well into the late-night hours. Montreal's island setting is dominated by Mount Royal, a park that provides a year-round refuge from the bustle of the surrounding city. From its crest there are superb views of the city and its magnificent harbour. La belle province richly deserves its name. The wooded hills and rustic farms are appealing in any season, but they are perhaps loveliest in the autumn, when the hills seem to burst into flame as the leaves turn colour. The Laurentian Mountains, north of Montreal, are a favoured recreational area for Quebec natives and visitors. Beautiful trails, good fishing and excellent skiing in the winter can all be found there. Another favourite area for touring is the Gaspé Peninsula. Ringed by picturesque fishing villages, its northern portion is an area of massive cliffs and rugged seascapes. At its tip is monolithic Percé Rock, a dramatic and ancient limestone outcropping that has been attracting painters, photographers and sightseers for centuries.

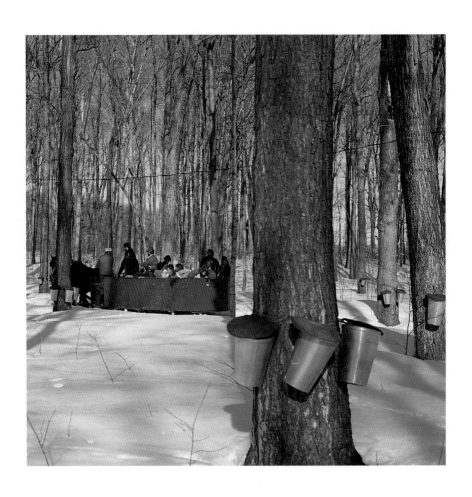

The old way of gathering maple syrup.

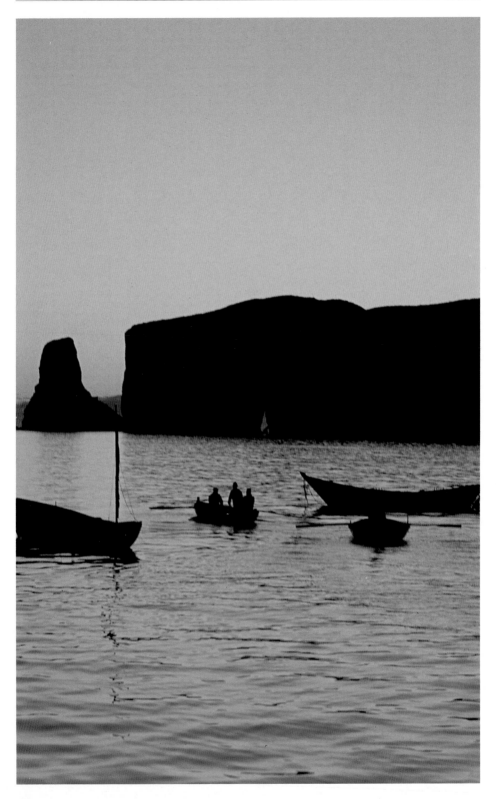

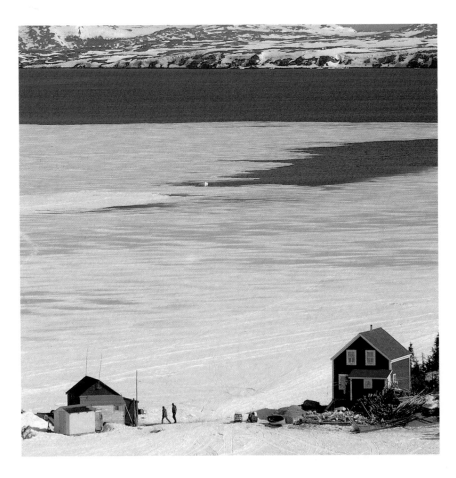

Above: *Near Harrington Harbour, Quebec.*

Left: *Percé Rock, Quebec.*

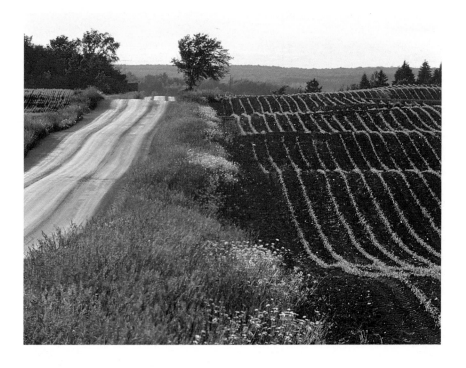

Near Weedon, Quebec.

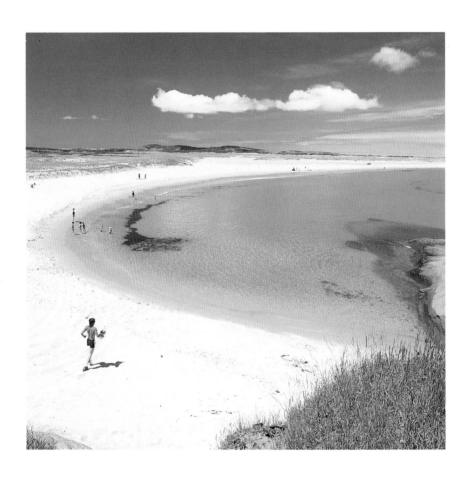

Old Harry Beach, Madeleine Islands.

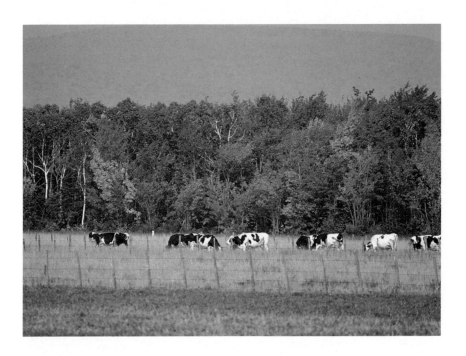

Fall colours, Quebec.

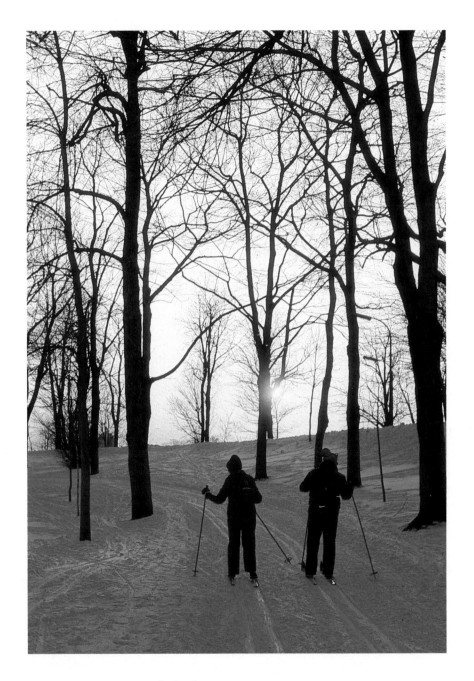

Mount Royal, Montreal, Quebec.

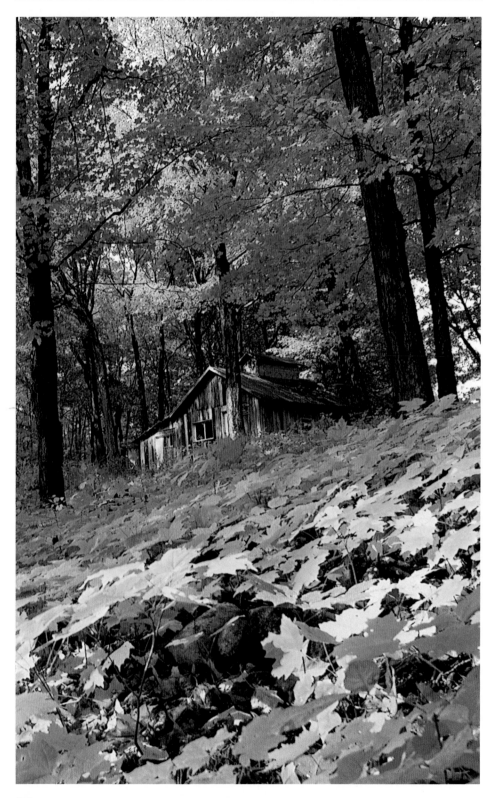

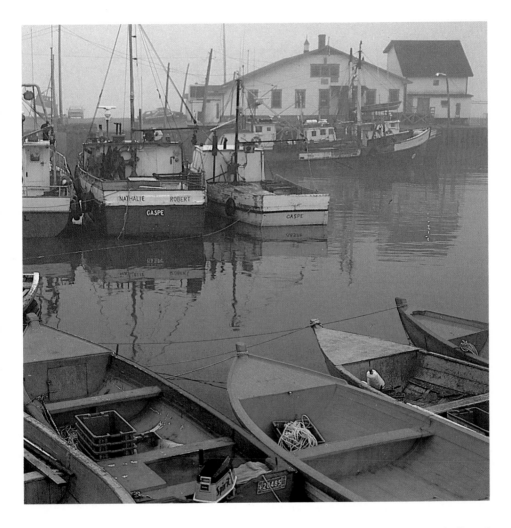

Above: *Ste-Thérèse-de-Gaspé, Gaspé Peninsula, Quebec.*

Left: *Rural woodland, Quebec.*

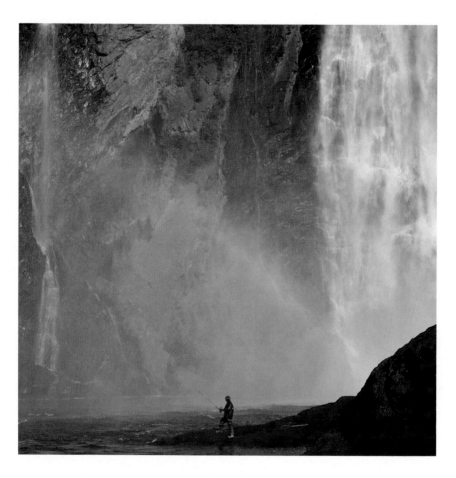

Above: *Montmorency Falls, Quebec.*

Right: *Quebec City, Quebec.*

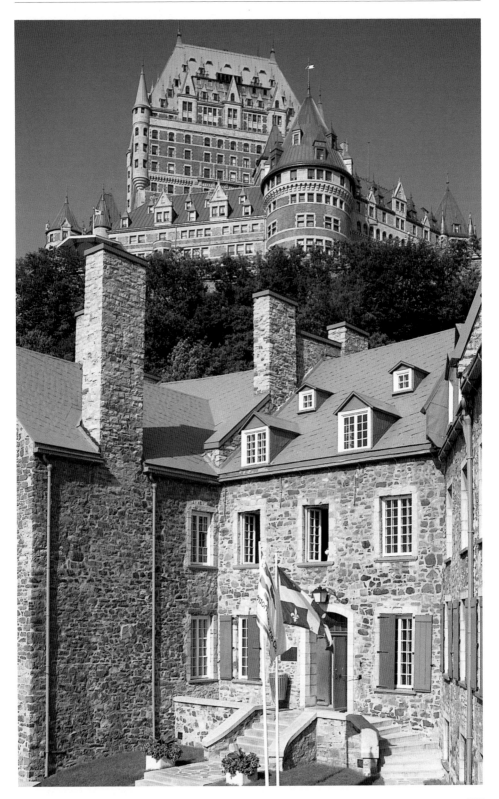

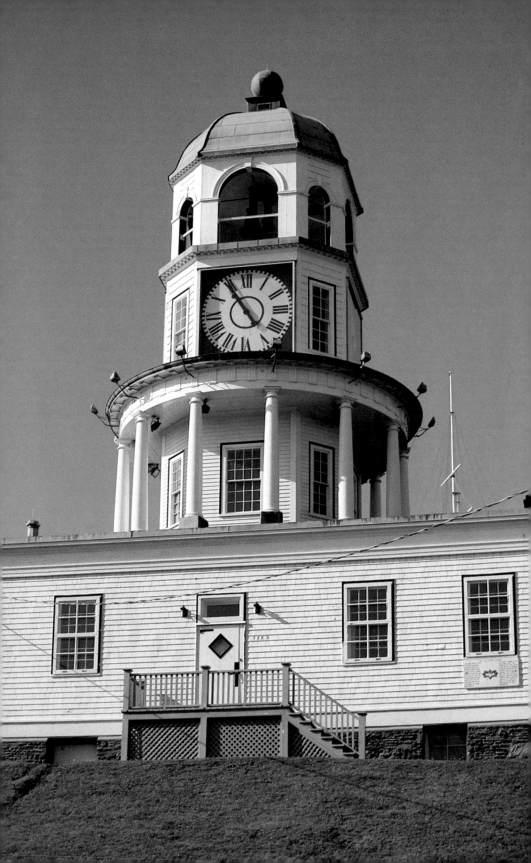

The Maritimes

New Brunswick, Prince Edward Island and Nova Scotia are collectively known as the Maritime Provinces. Although each province has its own character, the unifying factor is the overwhelming presence of the Atlantic Ocean. No part of these provinces is very far from the sea, and they are characterized by long sandy beaches, craggy windswept cliffs and deeply indented shorelines that provide safe harbour against the fury of the Atlantic.

A strong sense of the past pervades the Maritimes. Here the first settlers tamed a harsh new world, building churches, homes and grand public buildings from the materials the land offered—wood and stone. Today, these buildings preserve that history, as do many museums and historic sites.

New Brunswick is washed by the Atlantic on the east and south and bordered to the north by Quebec and to the west by Maine. Not surprisingly, American and French influences are strong here, and New Brunswick is officially bilingual. Fishing villages and farming communities dot the coast of New Brunswick, but the central area—the vast majority

Left: *The Town Clock, Halifax, Nova Scotia.*

of the province—is forestland. Forestry is a mainstay of the economy. The capital, Fredericton, is located in the heart of the province, on the beautiful St. John River. Once passable for its entire length in New Brunswick, this river was the main transportation route of early settlers. Today, the river has been dammed to provide hydroelectric power, but it remains one of Canada's most scenic waterways.

Nova Scotia is virtually an island, connected to New Brunswick only by the Isthmus of Chignecto—32 kilometres (20 miles) wide at its narrowest point. No part of Nova Scotia is more than 56 kilometres (35 miles) from the sea, and the maritime tradition is evident everywhere. Its island portion, Cape Breton, boasts a deeply forested interior and a wildly beautiful coastline. Nova Scotia has a long history. The first permanent settlement in Canada was at Port Royal, now a national historic park. The capital of the province is the port city of Halifax, a fascinating mixture of historic buildings and modern architecture. From Halifax, it is a short drive to the picturesque and much-photographed village of Peggy's Cove.

Prince Edward Island is Canada's smallest province. Just 224 kilometres (140 miles) long and from 6 to 64 kilometres (4 to 40 miles) wide, it is mostly low-lying and largely cultivated. Well known for its potato crops, it produces a wide variety of fruits and vegetables. The province is valued by visitors for its peaceful atmosphere and the beauty of its green fields and characteristic red soil. The shellfish of Prince Edward Island are a special treat, particularly its Malpeque oysters. The provincial capital, Charlottetown, is a gracious city of gabled houses and treed boulevards. The cradle of Confederation, Charlottetown hosted the 1864 conference that led to the foundation of Canada in 1867.

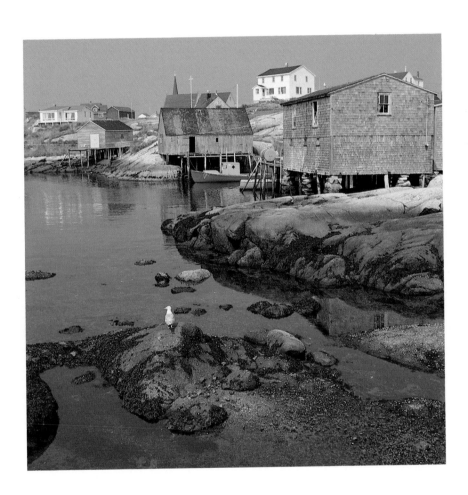

Peggy's Cove, Nova Scotia.

Above: *Fortress Louisbourg, Cape Breton Island, Nova Scotia.*

Right: *Fish weir, New Brunswick.*

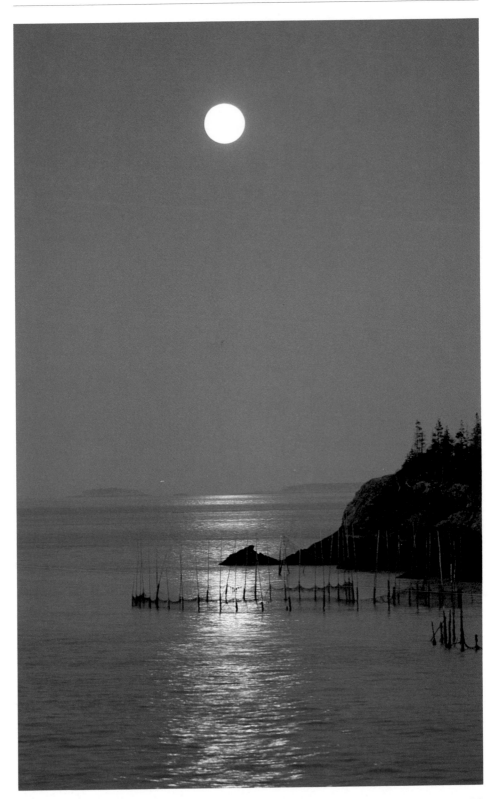

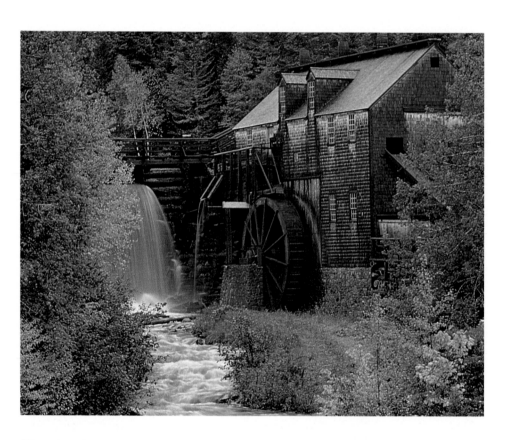

Kings Landing historical settlement,
New Brunswick.

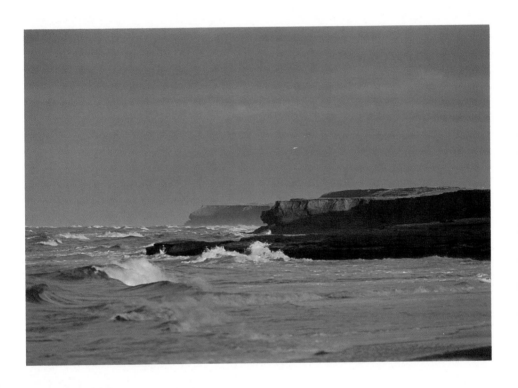

*Cavendish Beach, Prince
Edward Island.*

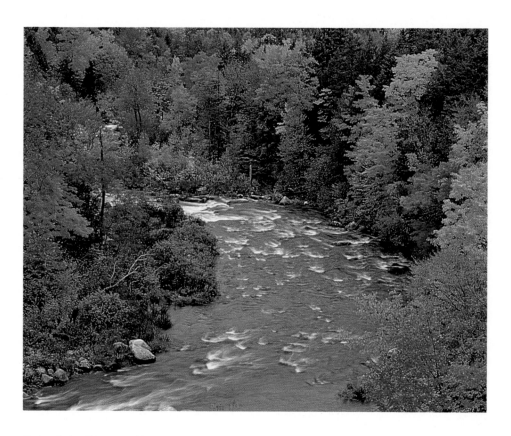

Saint John River Valley, New Brunswick.

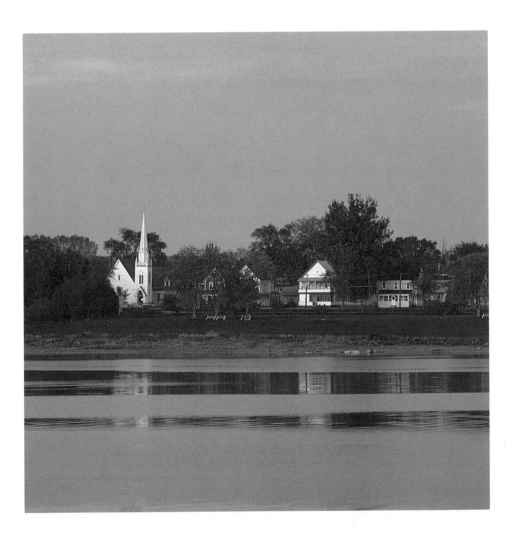

South Fredericton, New Brunswick.

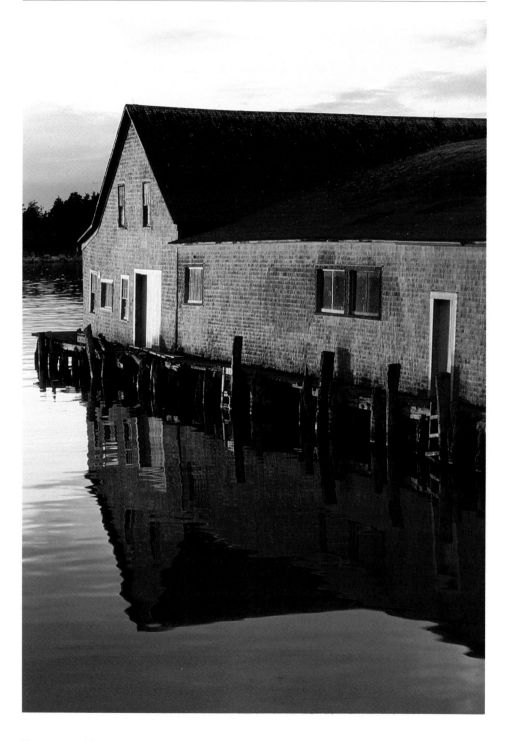

Yarmouth, Nova Scotia.

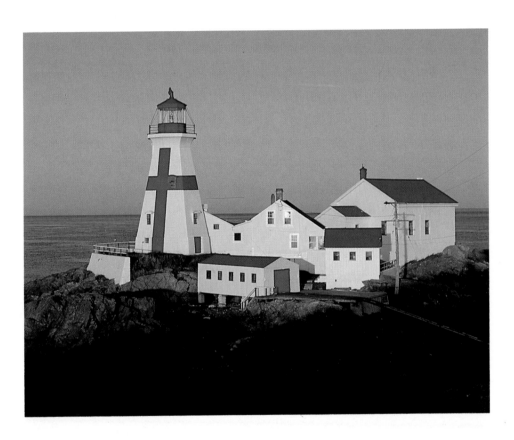

Campobello Island, New Brunswick.

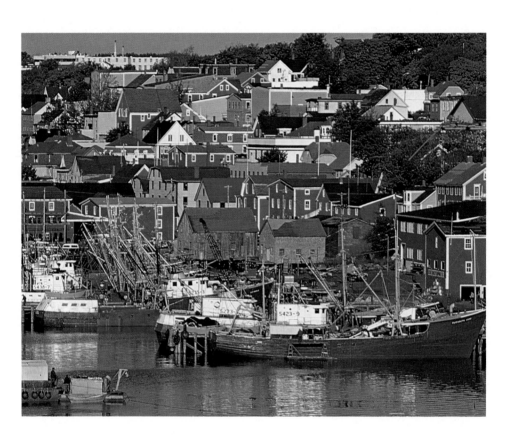

Lunenberg, Nova Scotia.

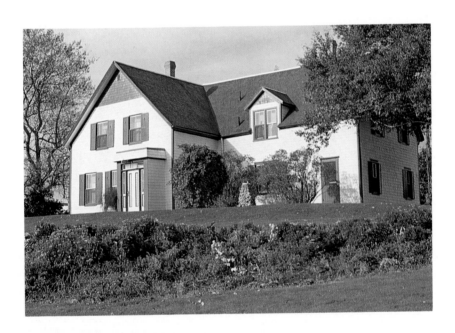

*"Green Gables," Prince Edward
Island.*

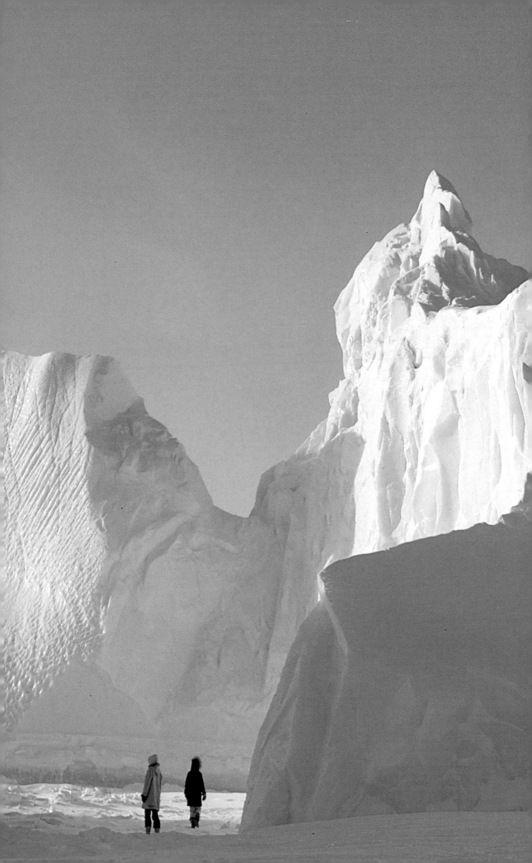

Newfoundland & the Northern Territories

Long before the rest of North America was discovered by European explorers, Vikings had crossed the Atlantic to visit the wooded shores of what is now Canada's most easterly province. Portuguese and Basque fishermen were already taking cod from the Grand Banks off Newfoundland by the time John Cabot anchored here in 1497. Small isolated settlements were established by British settlers; clinging to the rocky coast and battered by ocean storms, they changed very little for the next three centuries. This isolation served to preserve a unique culture. Even with today's modern methods of communication and transportation, many of these outports are unchanged, a heritage that is the essence of Newfoundland.

Colourful wooden houses brighten the streets of the capital city of St. John's, but Newfoundland's brand of austere beauty is evident even here. A variety of wildlife, from seals and sea lions to colonies of nesting

Left: *Canadian Arctic.*

seabirds, can be observed in several parks, notably Gros Morne and Terra Nova. Newfoundland's least populated area is its mainland territory, Labrador. Its forests and minerals are important to the province's economy, but the fishery remains Newfoundland's principal resource.

Canada's two northern territories—the Northwest Territories and the Yukon Territory—spread across the roof of the continent. This massive region comprises 40 percent of Canada's total area, extending from Alaska in the west to Baffin Island in the east and encompassing innumerable islands. The land varies from the jagged peaks of the St. Elias Range in the Yukon to rolling tundra and the boreal forests of its southern reaches. The sparse population endures sub-zero temperatures for much of the year, isolation and the long dark days of winter, when the sun barely peeks above the horizon before returning the land to night. Yet northerners are fiercely loyal, and those who visit the "Land of the Midnight Sun" usually find themselves caught in the web of its magic.

More than anywhere else in Canada, residents are dependent on nature's whim. The few permanent communities of the north are widely separated and vary from Yellowknife, capital of the Northwest Territories, which prides itself on up-to-date amenities, to tiny Tuktoyaktuk, on the east delta of the mighty Mackenzie River.

The Yukon had its first large influx of population with the Klondike Gold Rush of 1890. Since that time, the Yukon has been almost synonymous with gold for many people. The lure of the shiny metal is very much alive today, but other minerals, oil and tourism now support the economy. Its largest city, Whitehorse, is also the capital.

Many people are drawn to the north for the splendour of its untamed wilderness. Yukon's Kluane National Park boasts some of Canada's most scenic mountainscapes, including Mount Logan—at 5950 metres (19,520 feet) the tallest peak in Canada. Nahanni National Park and Wood Buffalo Park, Canada's largest national park, exemplify the rugged appeal of the Northwest Territories.

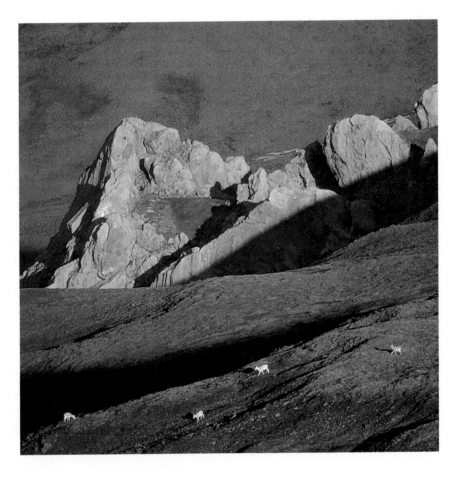

Dall sheep, Kluane National Park,
Yukon.

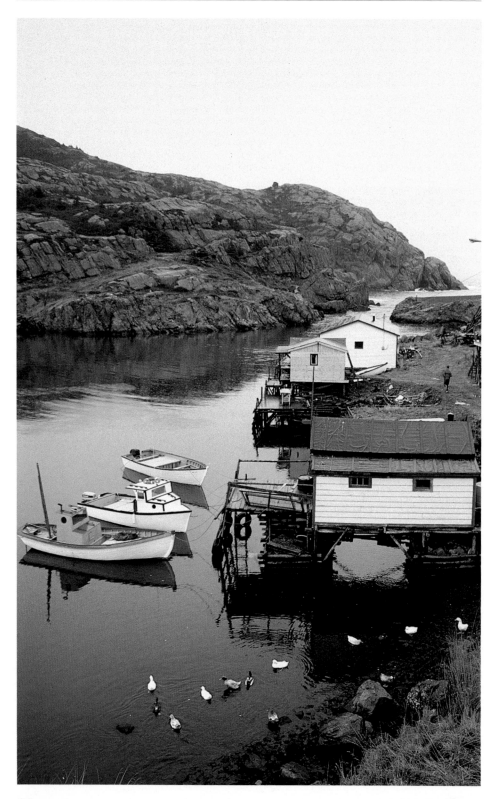

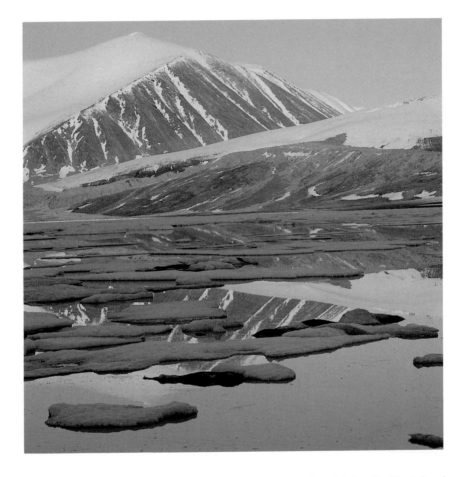

Above: *Pond Inlet, Baffin Island, Northwest Territories.*

Left: *Quidi Vidi, Newfoundland.*

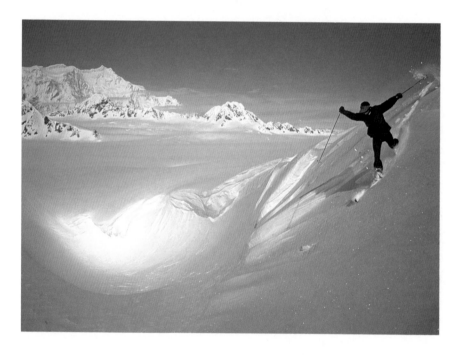

Ski mountaineering, Mount Logan,
Yukon.

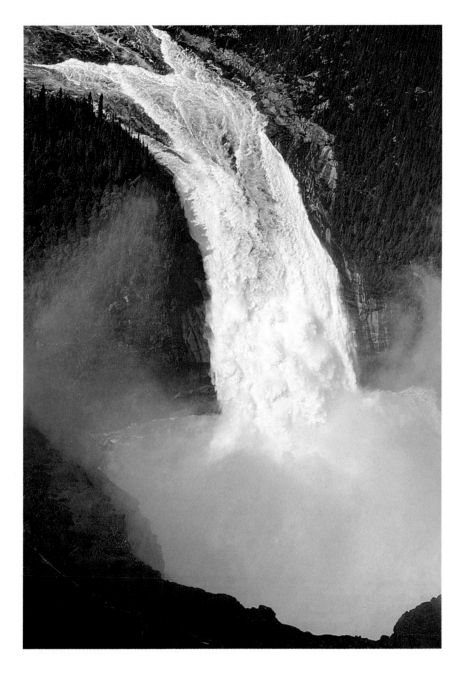

Churchill Falls, Labrador.

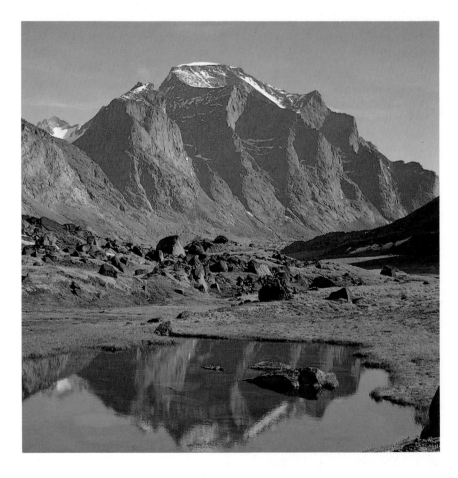

Mount Odin, Pangnirtung Pass,
Auyuittuq National Park, Northwest
Territories.

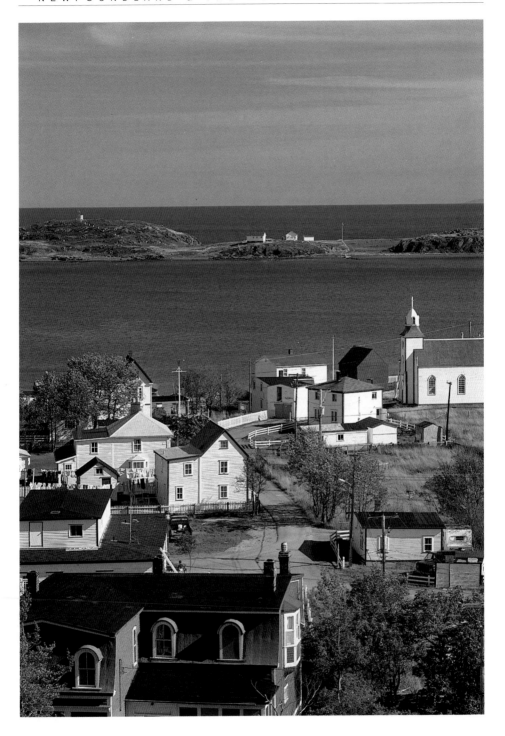

Trinity Bay, Newfoundland.

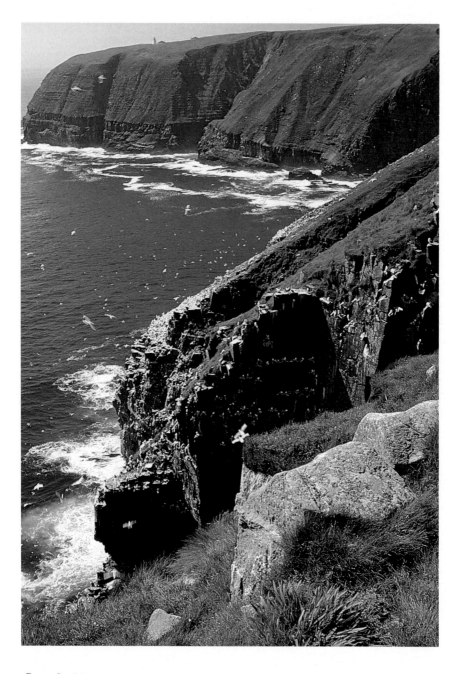

Cape St. Mary's, Newfoundland.

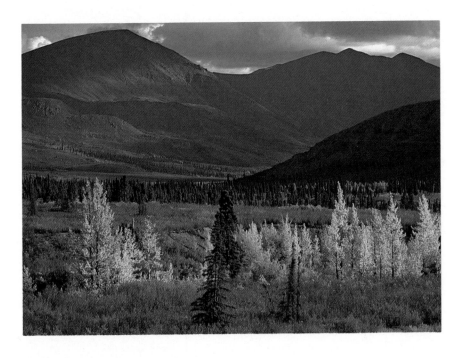

Ogilvie Mountains, Yukon.

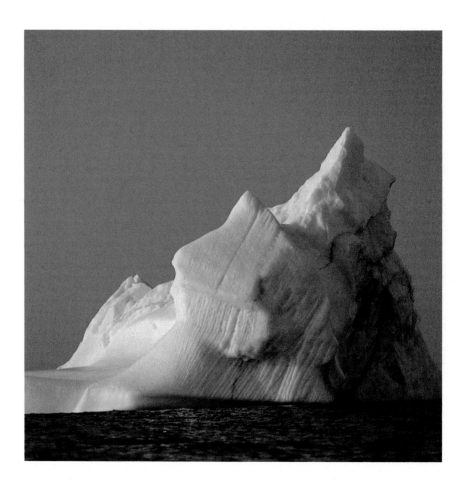

Iceberg, Atlantic coast,
Newfoundland.

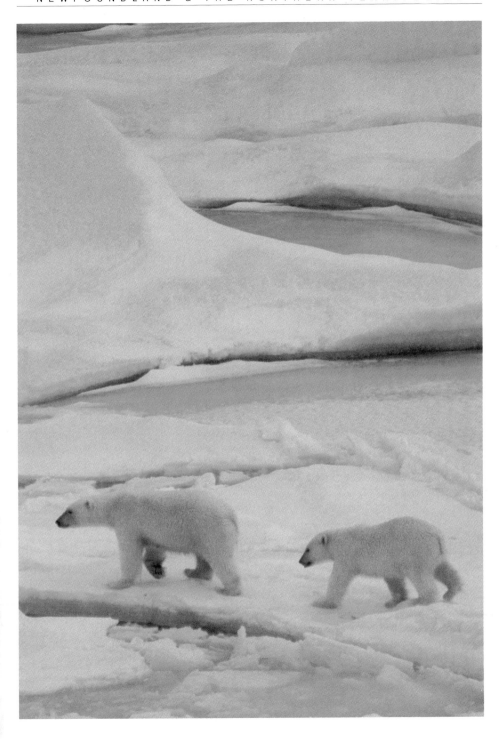

Polar bears, Beaufort Sea, Canadian Arctic.

Photo Credits

Marin Petkov p. 1
Al Harvey pp. 2, 5, 36, 47, 48, 53, 64, 68, 74, 77, 96
Michael E. Burch pp. 6, 9, 11, 14, 16, 17, 23, 24, 28, 30, 32, 33, 45, 54, 59, 63, 78
Rick Marotz p. 10
Ed Gifford p. 12
Bob Herger pp. 13, 15, 18, 25
Carolyn Angus p. 19
Cameron Young p. 20
J.A. Kraulis pp. 26, 52, 57, 60, 70, 75, 84, 86, 88, 90, 99, 102, 104
Richard T. Wright pp. 27, 62, 91
J.R.A. Burridge pp. 29, 82
Patrick McGinley p. 31
Roger Laurilla p. 34
Lloyd Sutton p. 35
Susan and Ralph Klassen pp. 39, 42, 43
Jurgen Vogt pp. 40, 44, 46, 51, 61, 72, 73, 85, 87, 89
Saskatchewan Government Photo p. 41
Al Robinson pp. 55, 58
Dunkin Bancroft pp. 56, 67, 69, 71, 76, 81, 97, 100
Irving Weisdorf & Co. Ltd. pp. 83, 92
Fred Chapman p. 95
Pat Morrow pp. 98, 103
Doug Hankin p. 105
Four By Five p. 101